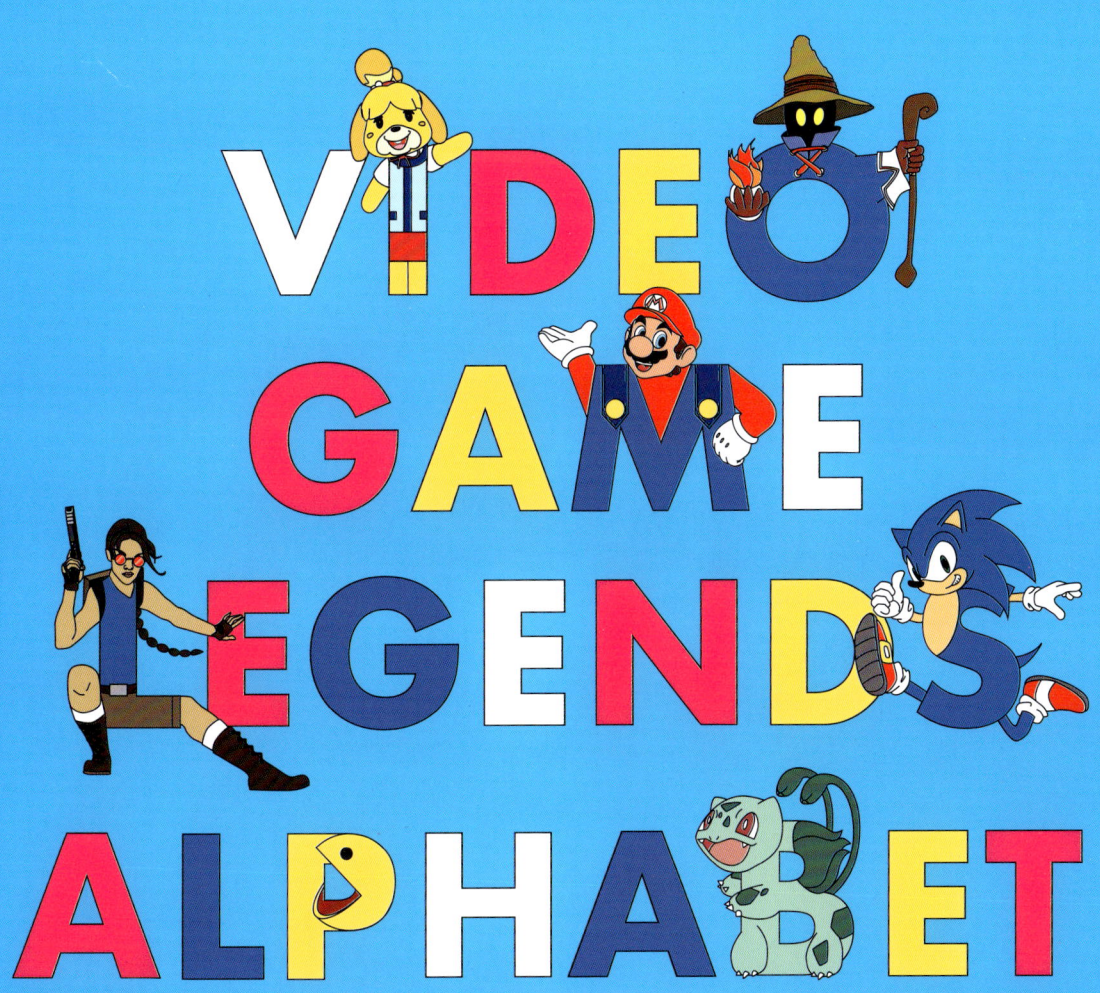

Words by Robin Feiner

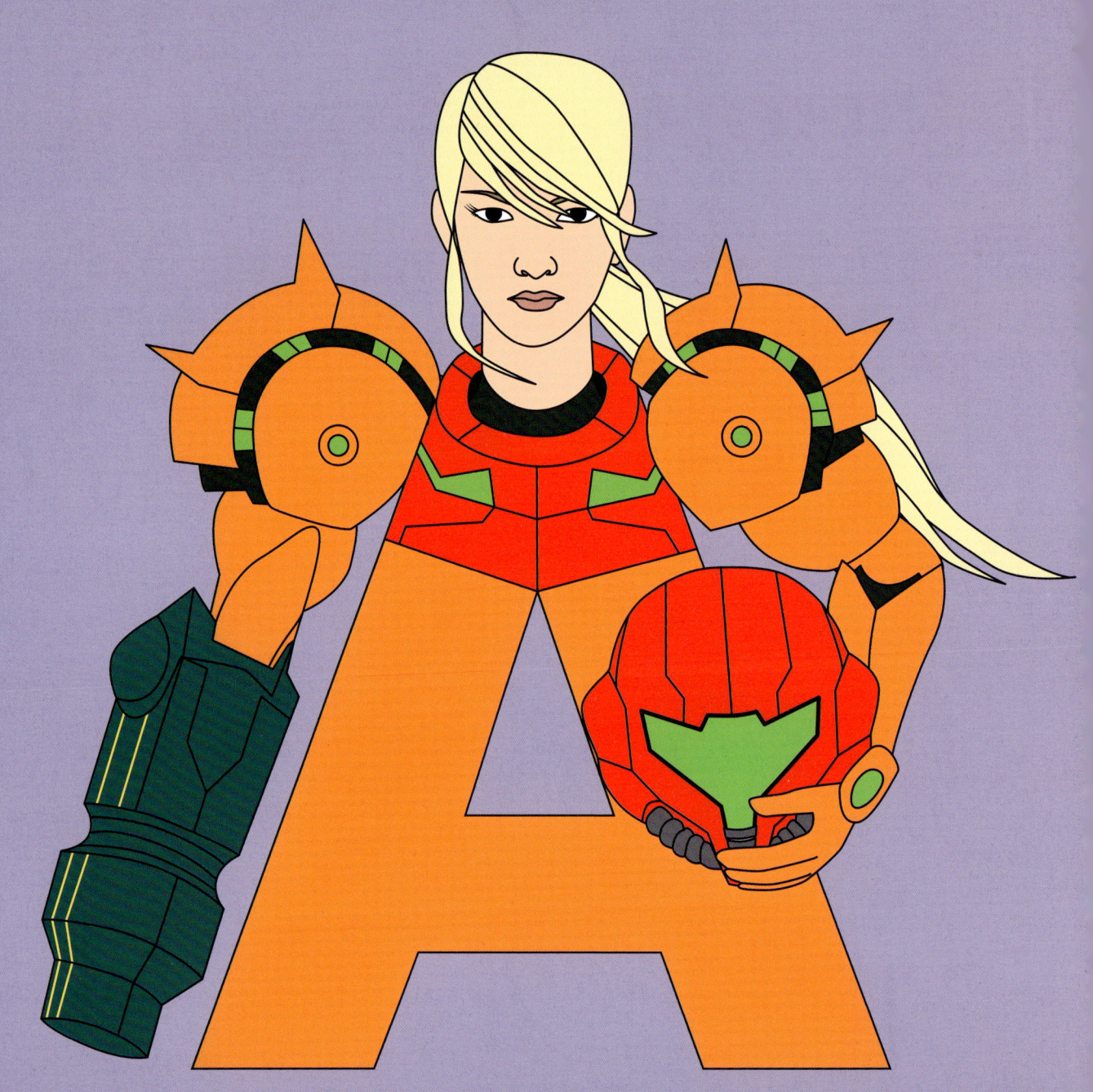

Aa

A is for Samus **A**ran. Few know her face, but many feel her wrath. This intergalactic bounty hunter fights Space Pirates seeking to turn Metroids into weapons. Just ask Ridley and Mother Brain how deadly Samus' Power Suit, arm cannon, and Grapple Beam are.

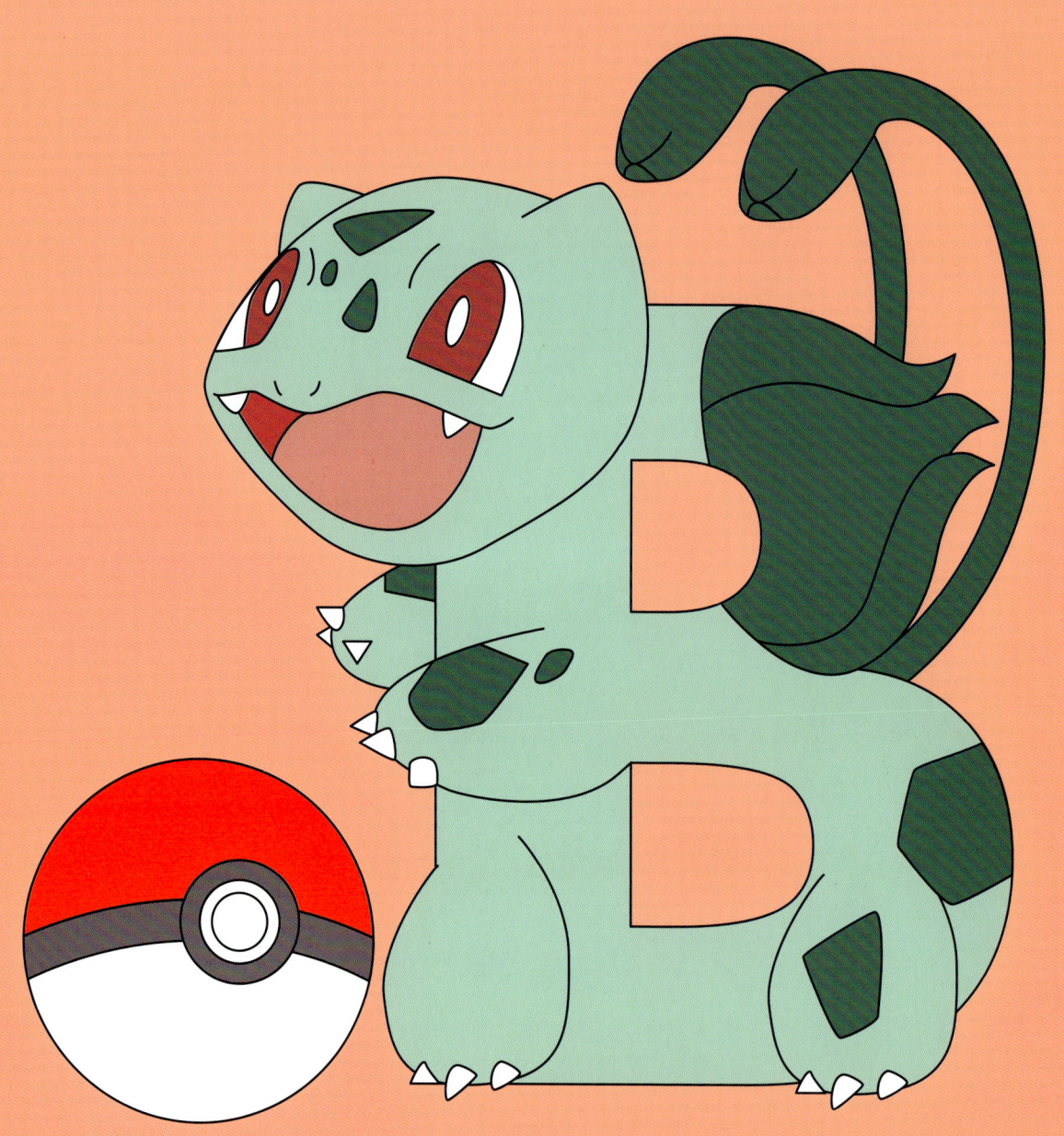

Bb

B is for **B**ulbasaur.
Bulba bulba! Like fellow Pokémon Squirtle, Charmander, and Pikachu, Bulbasaur provides trainers with legendary power for battles. This grass/poison Pokémon uses moves like Vine Whip, Tackle, and Leech Seed to crush enemies. Look out, gym leaders!

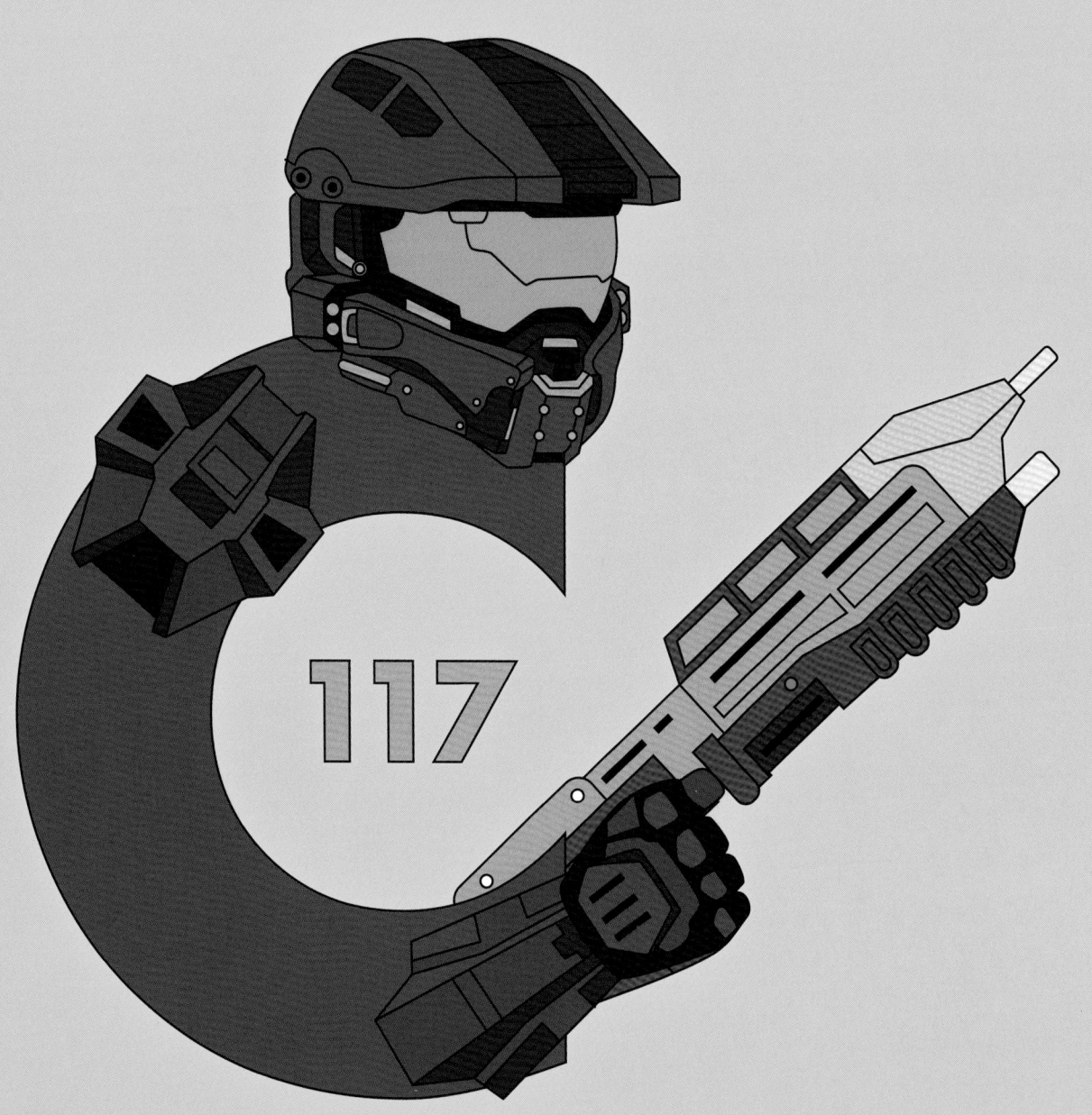

Cc

C is for Master Chief.
Asking isn't his strong suit.
Master Chief is a hard-nosed
Spartan supersoldier who
wages a futuristic war against
Covenant aliens. He uses
his signature body armor,
powerful weaponry, and
reliable Cortana AI to vanquish
enemies on Halo and beyond.

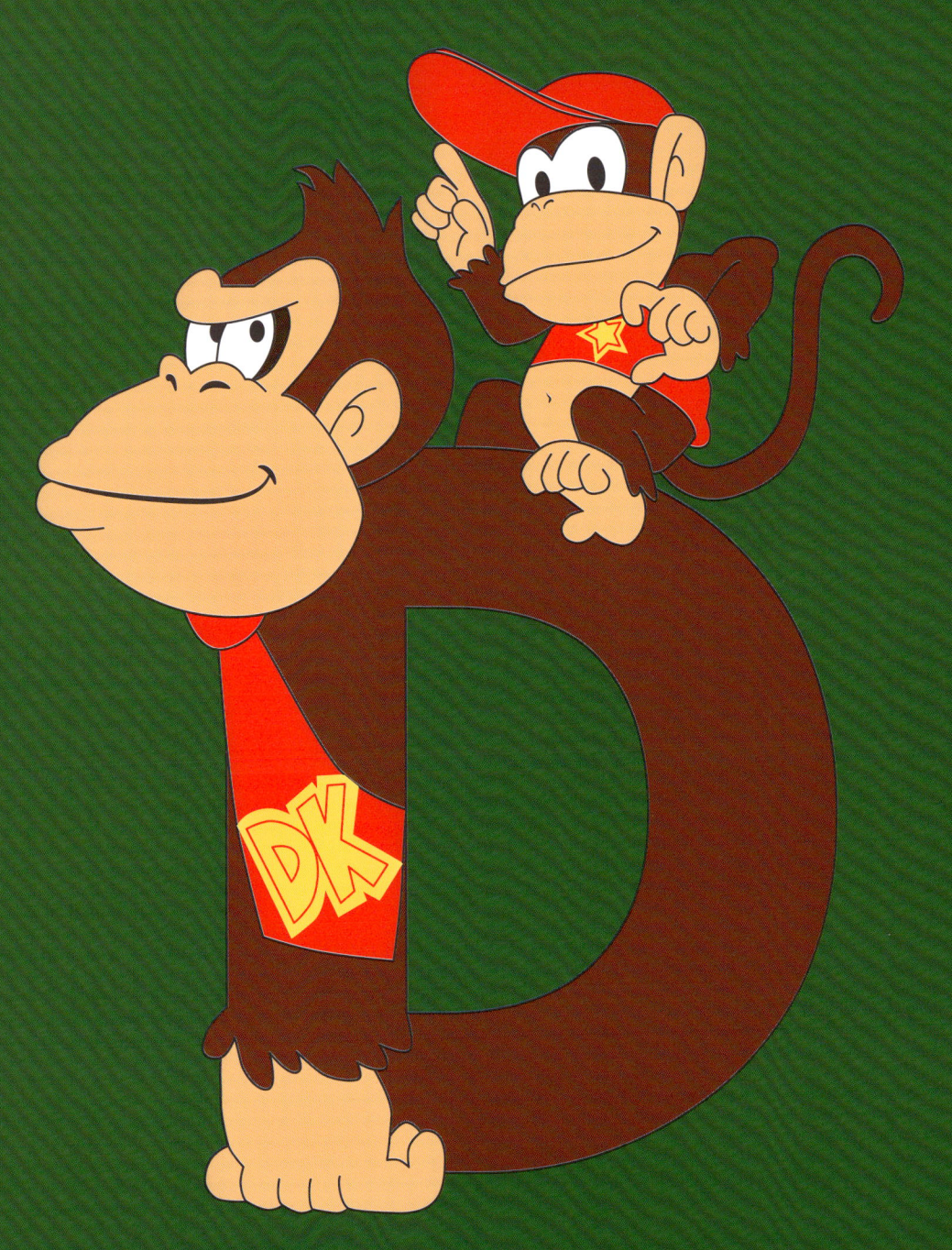

Dd

D is for **D**onkey Kong.
DK and his gorilla family are always up for some monkey business! His grandpa might be busy chucking wooden barrels at Mario, but Donkey Kong and his nephew Diddy fight to save the family banana collection from King K. Rool and his fearsome Kremlings.

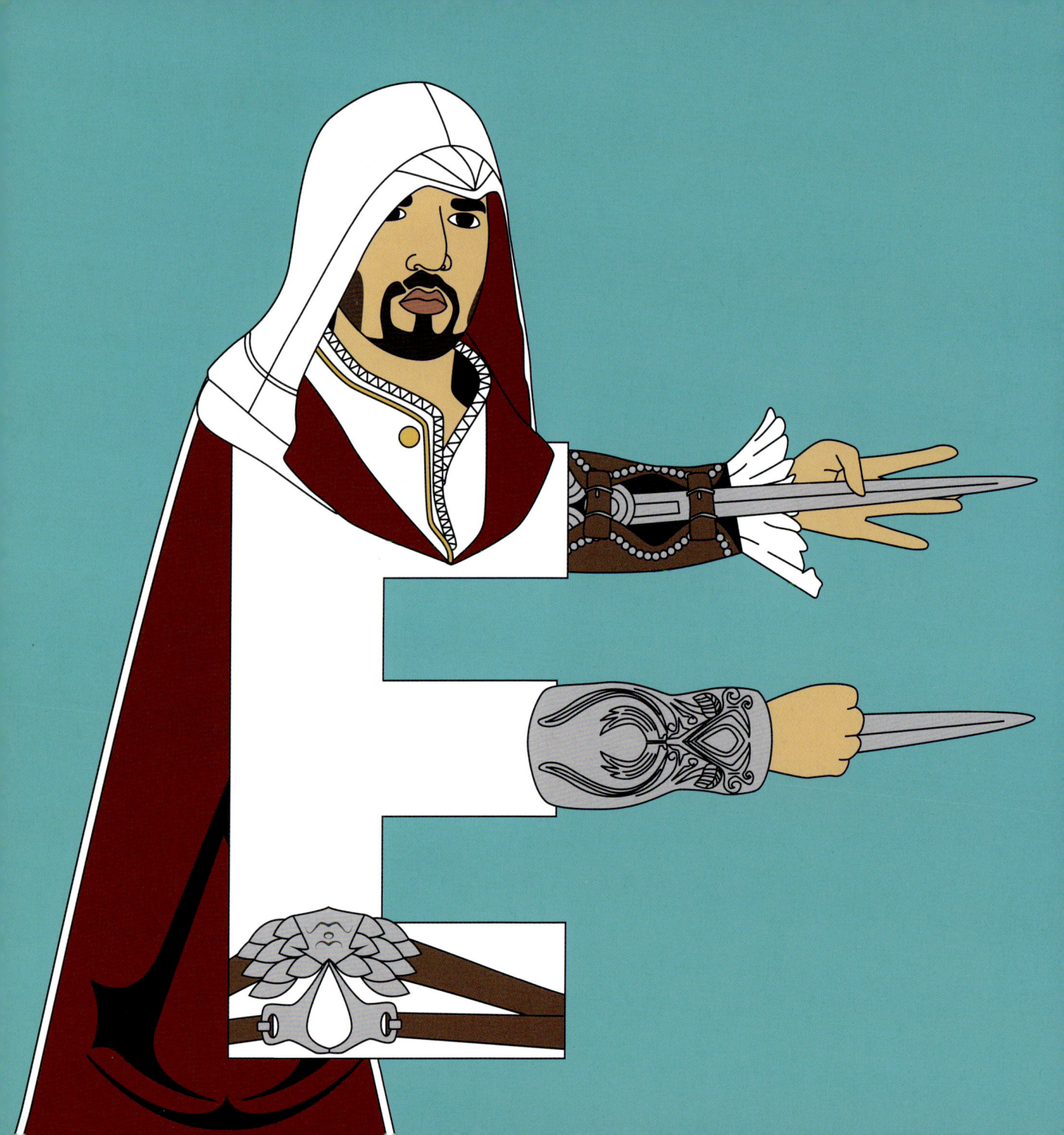

Ee

E is for **E**zio Auditore.
Ezio is the deadly Italian who returned glory to the Order of Assassins. He leads his brotherhood against the Templar Order, toppling powerful villains, capturing vital artifacts, and unearthing conspiracies. The lives of his enemies are often left to fate.

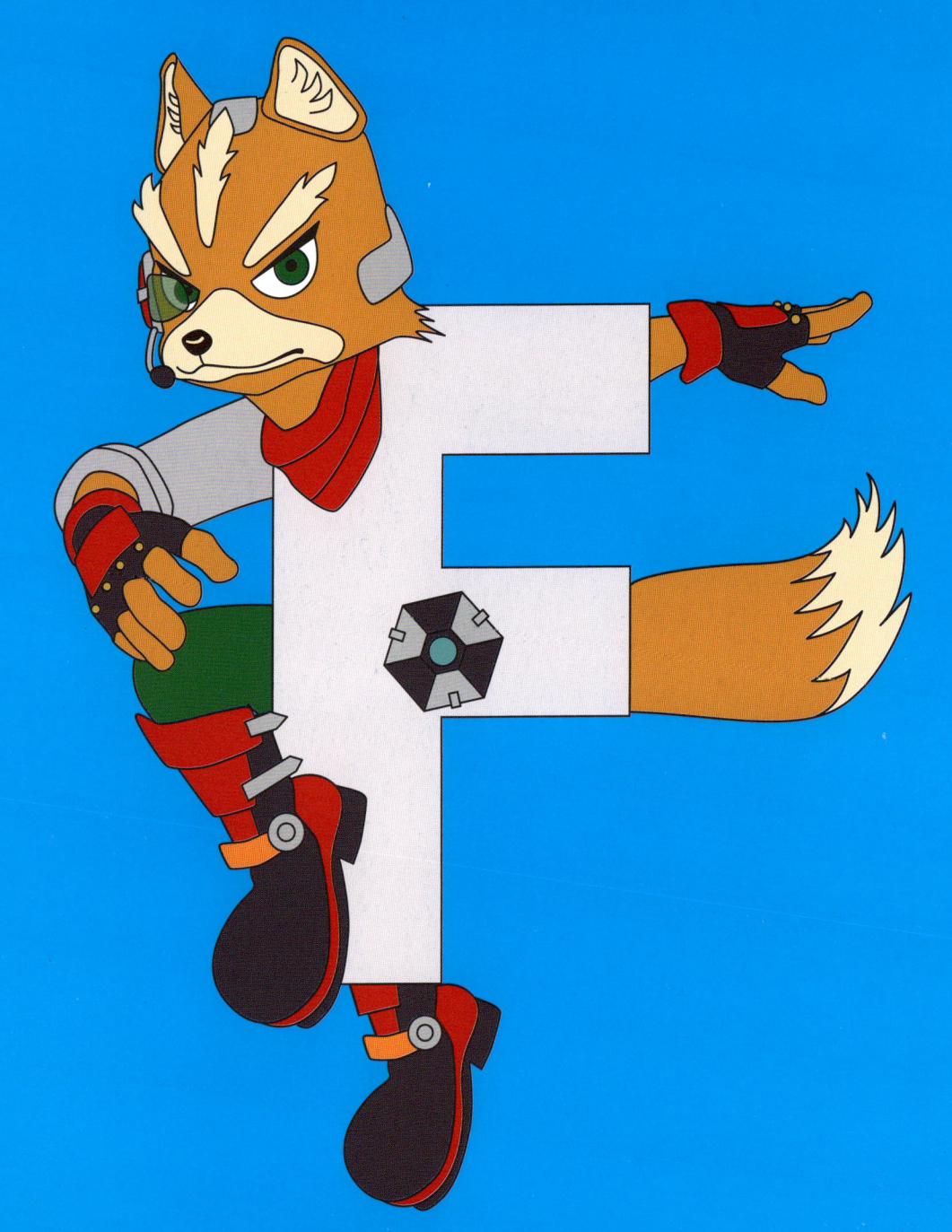

Ff

F is for Fox McCloud. This ace Arwing pilot and barrel roll expert straddles the line between cocky and confident. He's a surefire Lylat System legend, routinely outsmarting the Star Wolf team with help from Falco, Peppy Hare, and the rest of the Star Fox squadron.

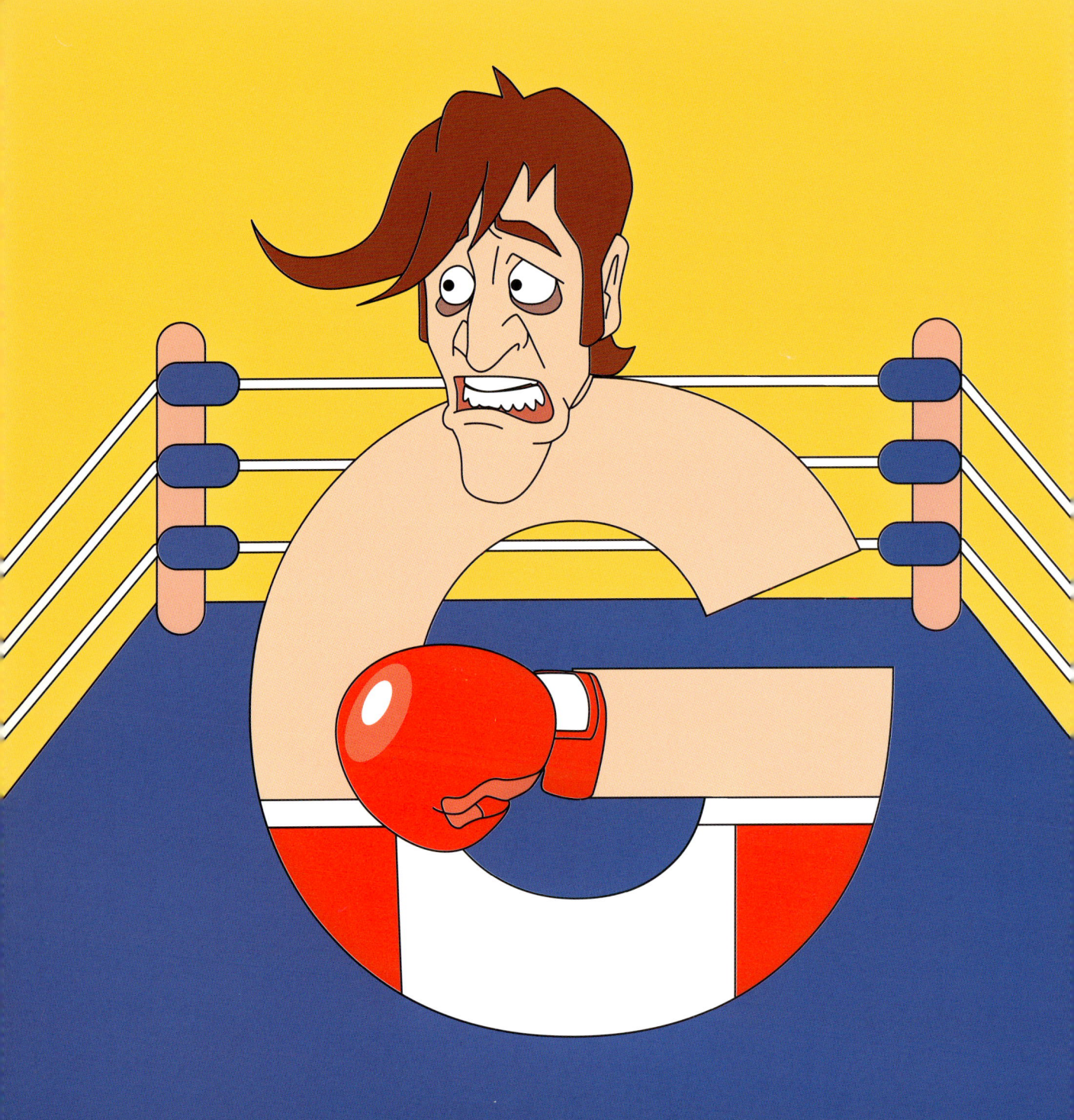

Gg

G is for Glass Joe.
Vive la France! This French boxer can take a punch … just not very well! With a monumentally poor record of 1-99, an awful Taunt Punch move, weak jabs and hooks, and poor defense, Glass Joe has earned his "France's Glass Jaw" nickname.

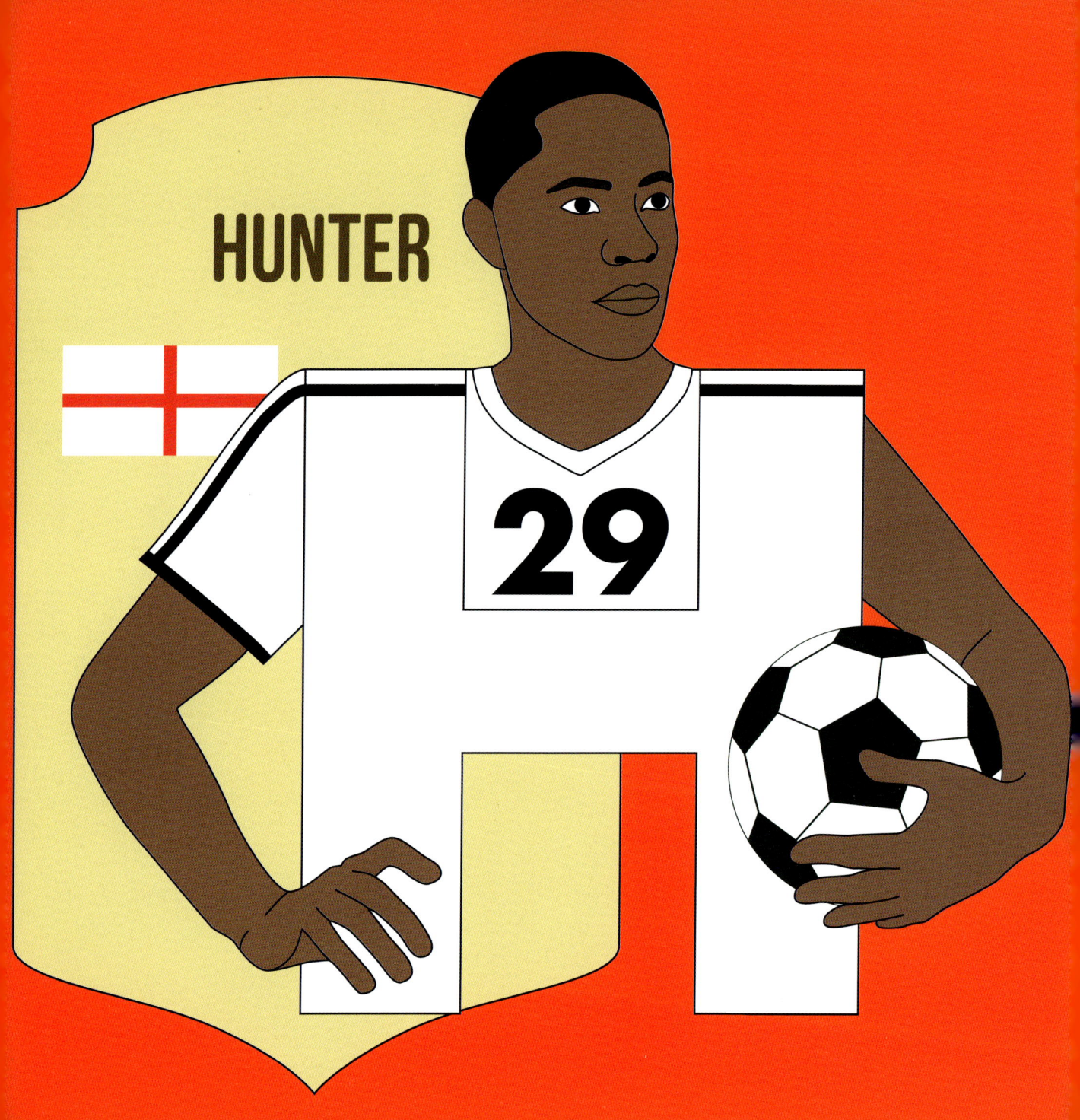

Hh

H is for Alex **H**unter. From Clapham pitches and Brazilian favelas to some of the world's most impressive stadiums, Hunter's ascendant rise to soccer stardom is nothing short of legendary. Years of training, toiling in lower leagues, and facing the game's best are all part of the journey.

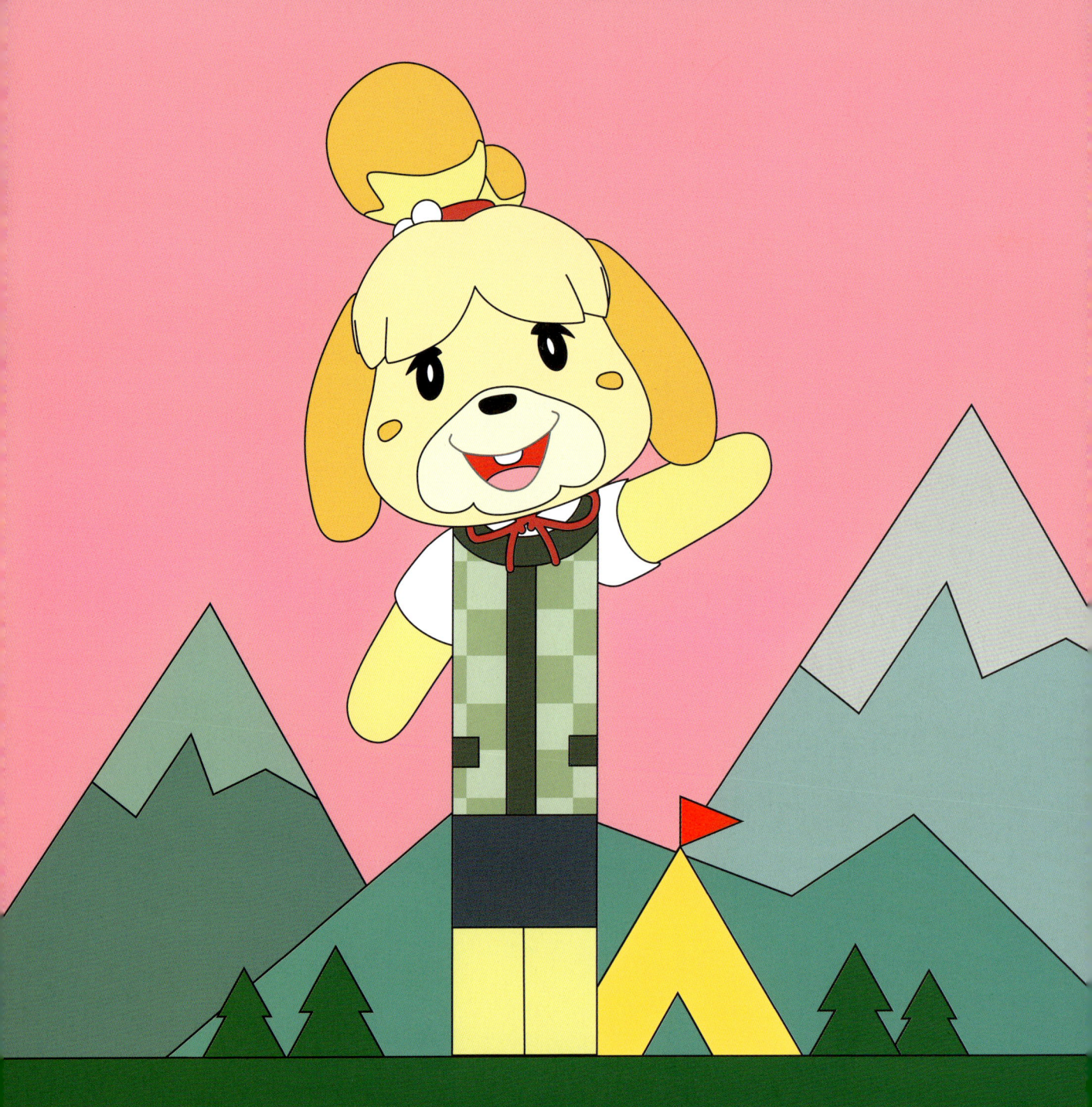

Ii

I is for Isabelle.
A hard worker who cares about her community, this little legend is always ready to help out the mayor. As secretary and advisor, she knows what everybody is up to around town! She's never afraid to step in and sort out issues when called upon.

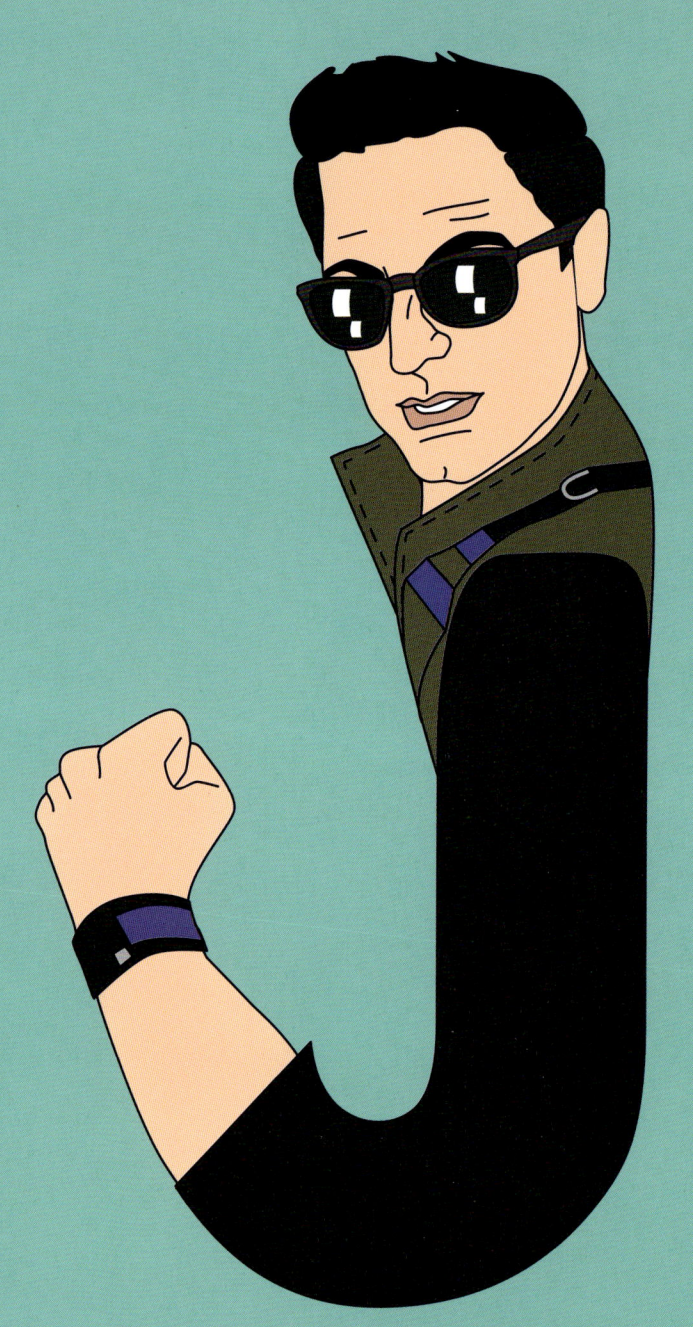

Jj

J is for **J**ohnny Cage.
Not just a cool pair of shades, famed fighter Johnny Cage is as legendary on action movie sets as he is defending Earthrealm in the Mortal Kombat Shaolin Tournament. Shadow kicks, split punches, a deadly uppercut — Cage has all the moves.

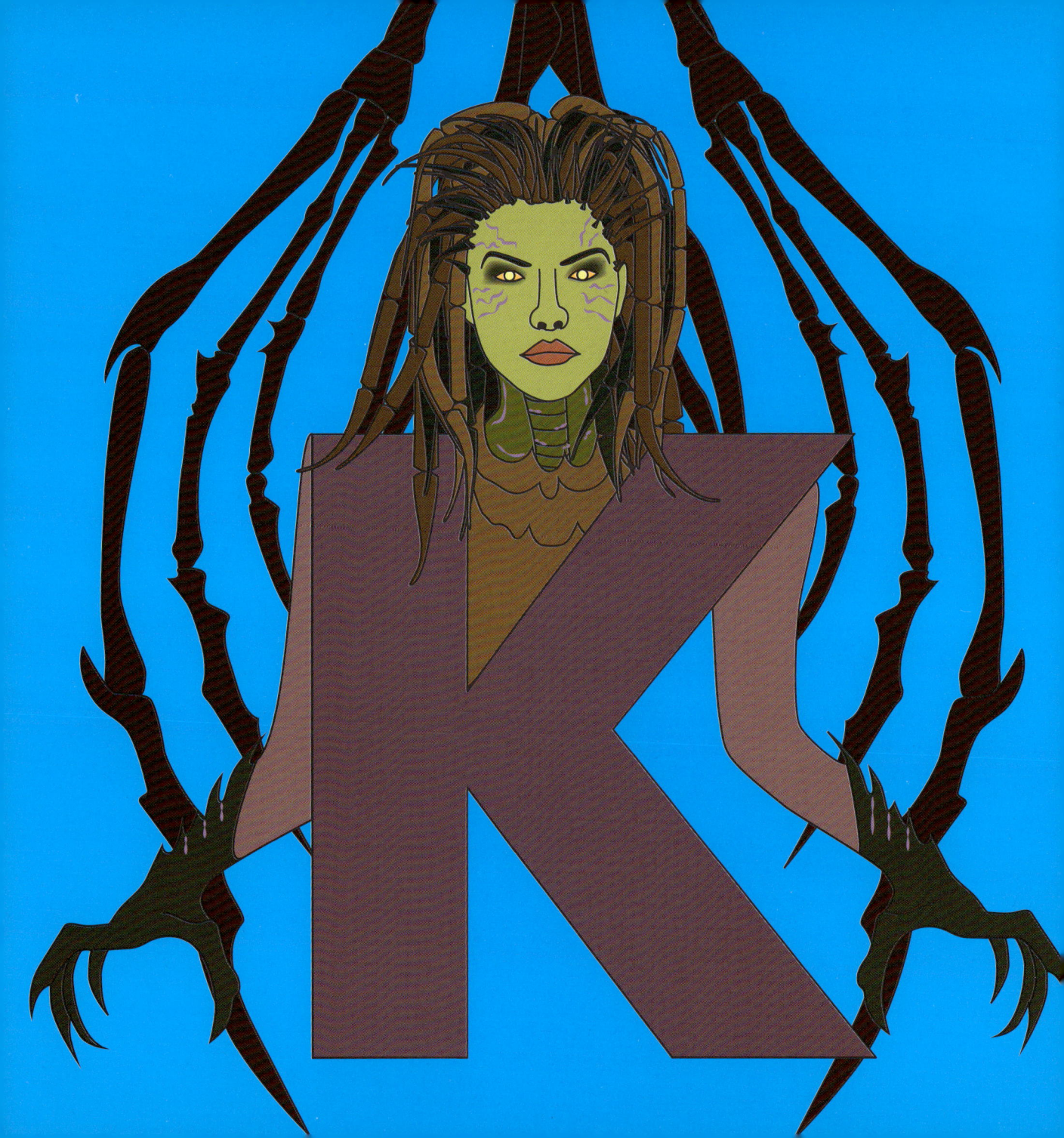

Kk

K is for Sarah **K**errigan. Sarah Kerrigan's life took quite a turn. Initially a psychic and Sons of Korthal freedom fighter, she was captured and infested. She then became Queen of Blades and head of the villainous Zerg. Now she is the swarm, and vengeance will be hers.

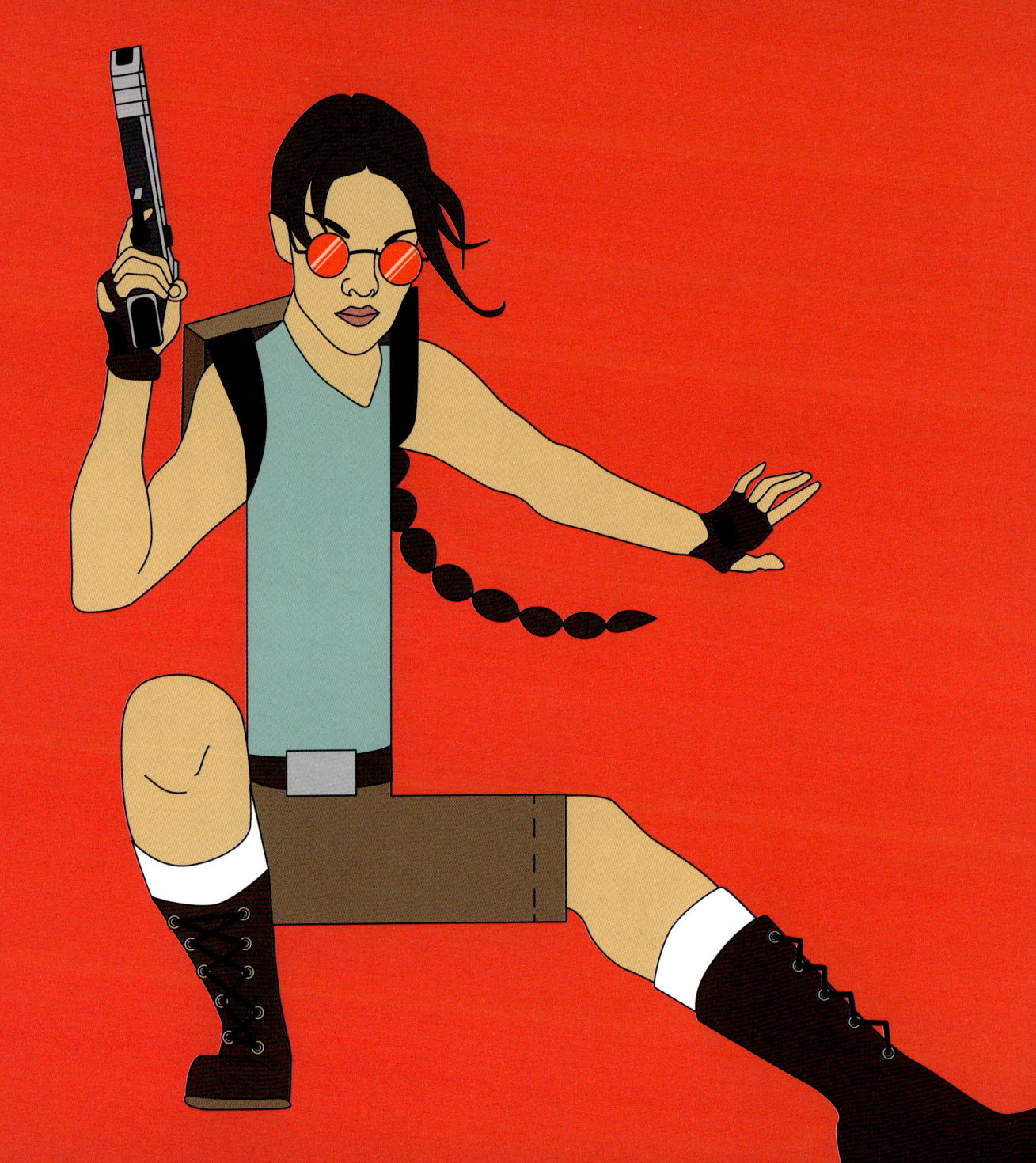

Ll

L is for Lara Croft.
This gun-toting, puzzle-solving, death-defying legend travels to all corners of the world. Lara refuses to let vicious mummies, deadly villains, or terrible traps stop her from raiding tombs, discovering ancient artifacts, and unearthing the truth.

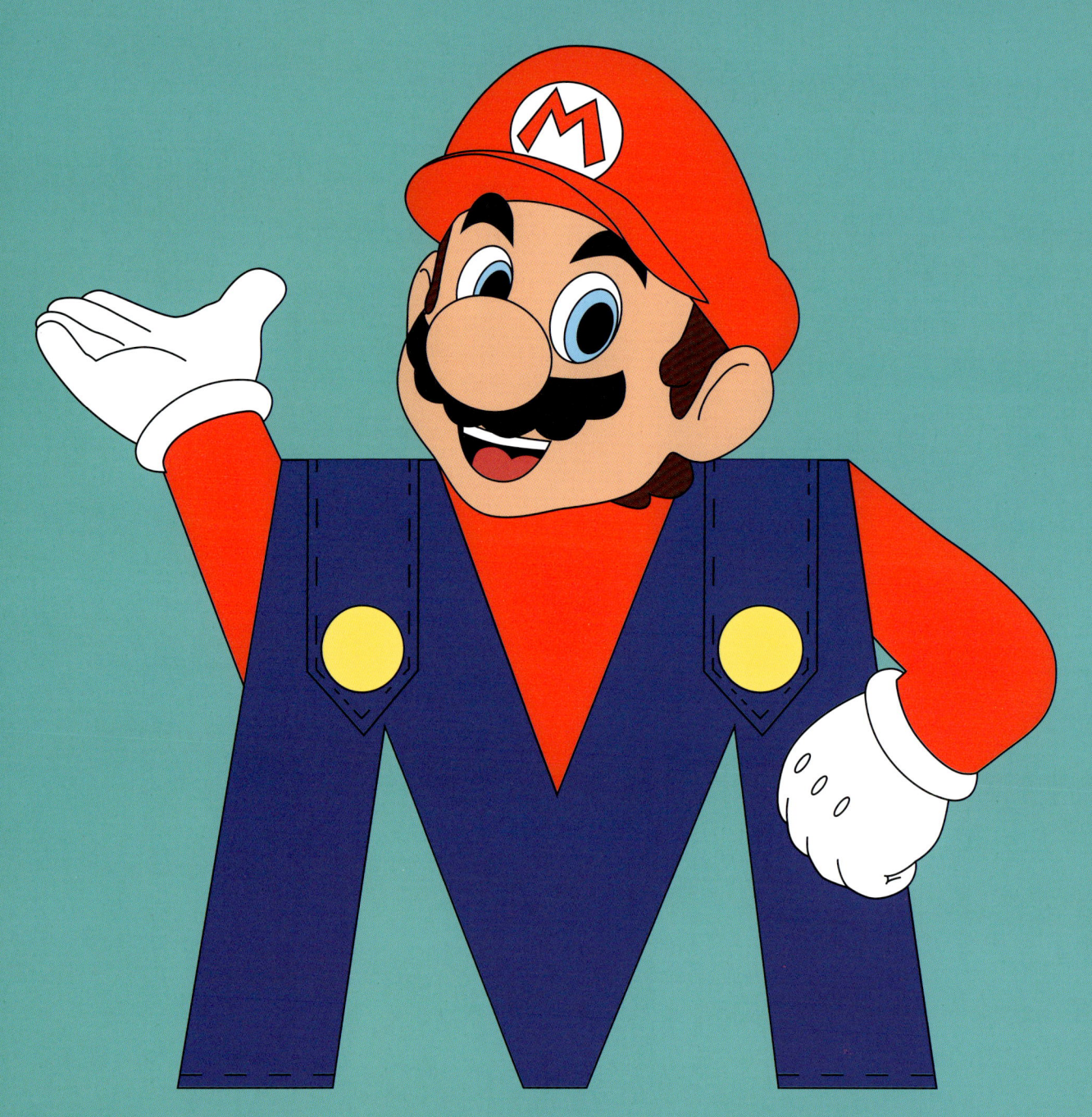

Mm

M is for Mario.

It's-a him, Mario! This cheery, red-hatted plumber fearlessly battles Goombas, Koopa Troopas, and Bowser as he makes his way through the Mushroom Kingdom to save Princess Peach. He's tough with a Fire Flower, and he's not bad behind the wheel, either!

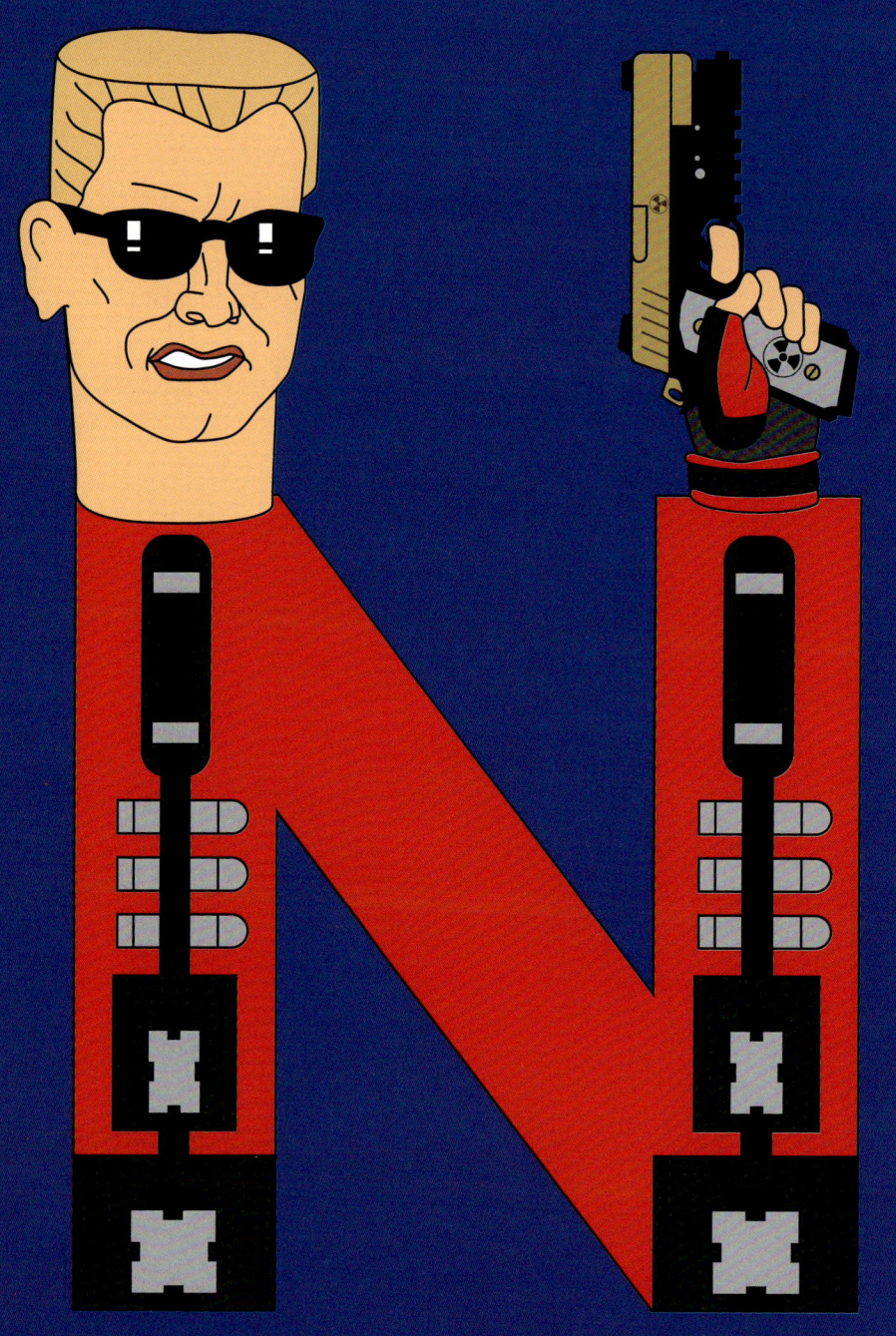

Nn

N is for Duke **N**ukem.
Duke is a heavy-hitting macho man with a mighty boot ... and he's all out of bubble gum. He's a wisecracker who fights alien scum with his jetpack and arsenal of weapons — everything from pistols and pipe bombs to shrinkers and shotguns. Groovy!

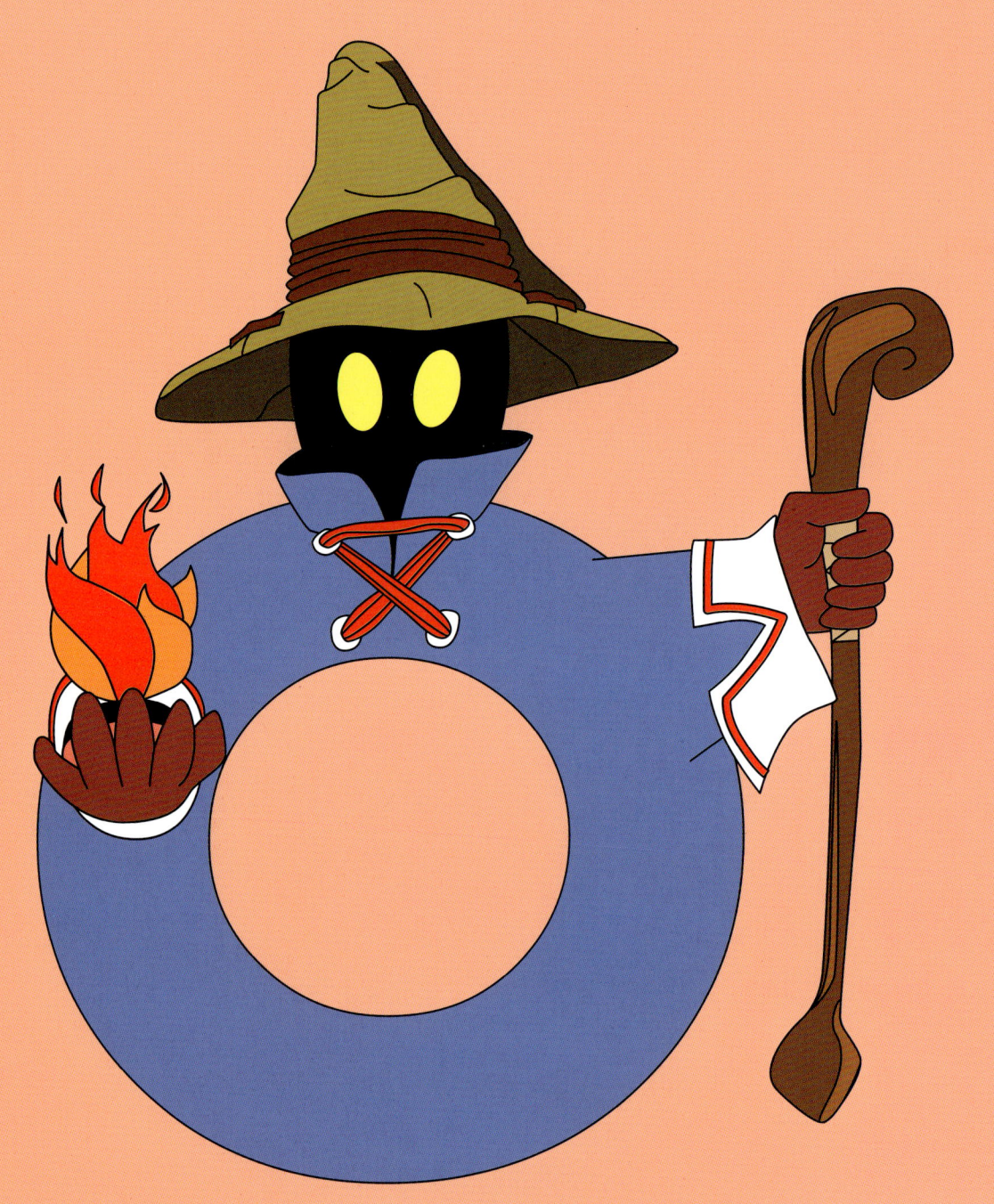

Oo

O is for Vivi **O**rnitier. He might be a shrimpy shy guy, but he's not lacking in heart. A black mage with an unusually bright soul, Vivi uses his elemental magic powers and staves to help his traveling party defeat enemies. A true loyal legend!

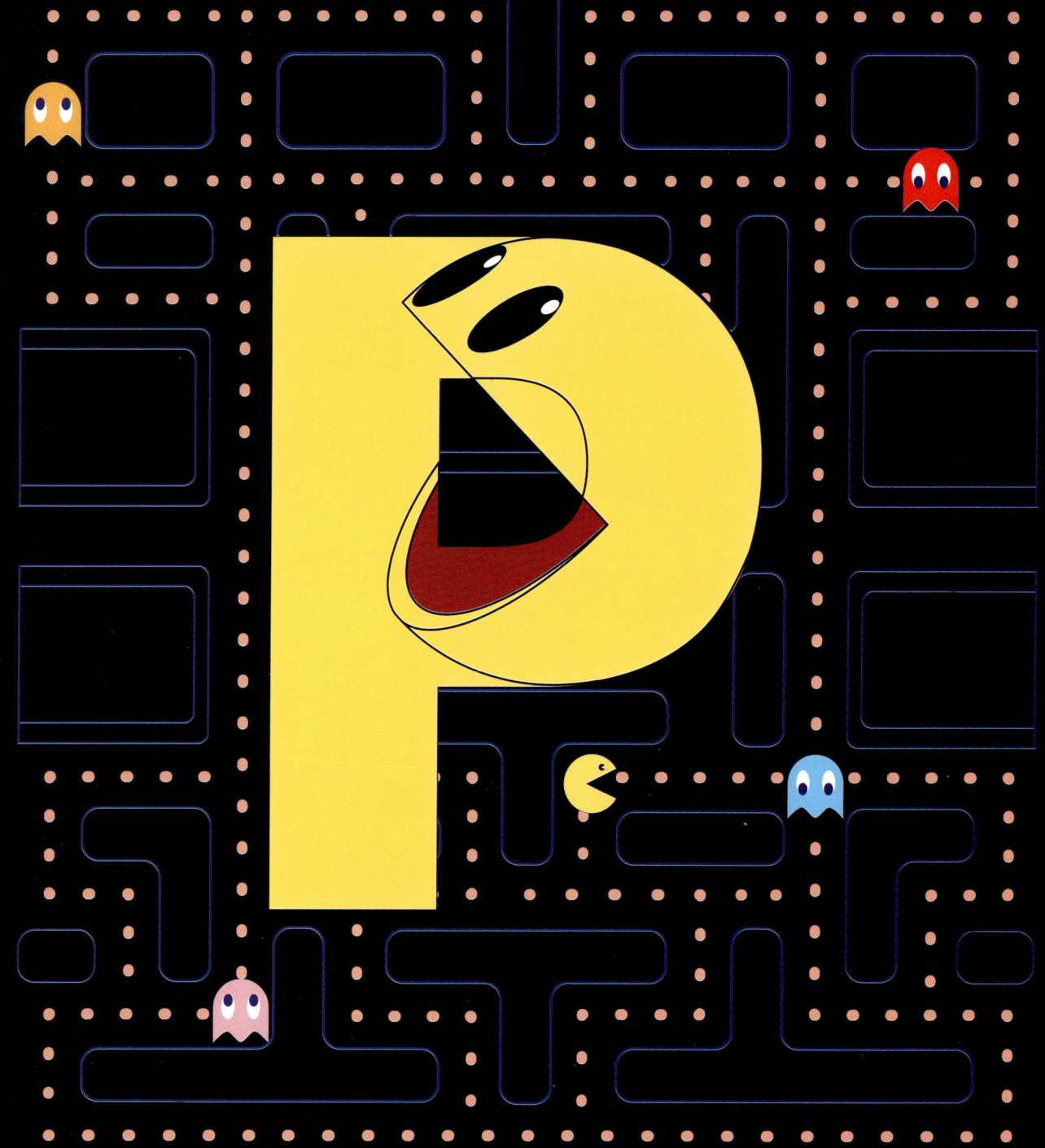

Pp

P is for **P**AC-MAN.
An a-maze-ing legend.
PAC-MAN gobbles up dots,
fruit, and other goodies
while avoiding Inky, Blinky,
Pinky, and Clyde. That is,
until PAC-MAN chomps down
on a power pellet, which lets
him chase down the ghosts
as they flee!

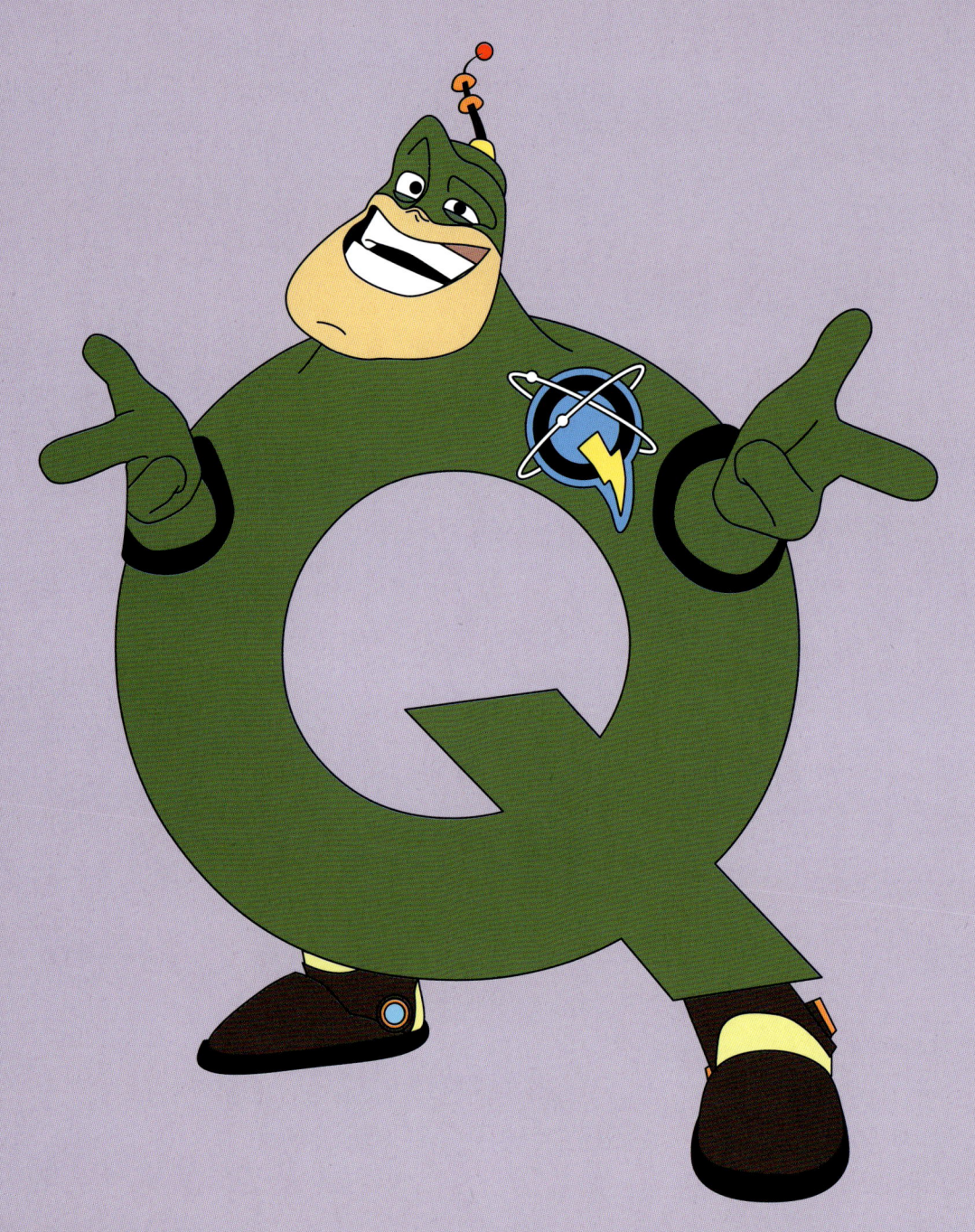

Qq

Q is for Captain **Q**wark. Sometimes it takes a legend a while to find his way. Driven by fame and fortune, Captain Qwark initially tried to kill heroes Ratchet and Clank. He eventually found inner peace and began using his immense powers and weapons to fight alongside the duo.

Rr

R is for **R**yu.
Despite winning numerous combat tournaments, Ryu remains committed to becoming a martial arts master. Whether he's unleashing devastating Tatsumaki Hurricane Kicks or crushing Shoryuken Dragon Punches, this legendary Street Fighter knows how to inflict some serious damage.

Ss

S is for **S**onic the Hedgehog. He's the fastest legend alive! Sonic is a bolting blue blur who uses his super-speed, smarts, and humor to stop Dr. Robotnik from capturing Chaos Emeralds and taking over the world. Giant loops, steep slopes, bouncy springs — they're no problem for Sonic.

Tt

T is for **T**ony Hawk.
The Birdman is the most iconic Pro Skater of all time. He pulls off insane aerials, flips, grinds, and manuals everywhere from abandoned warehouses to bullfighting rings to Roswell's Area 51. And he's always got an awesome soundtrack to match.

Uu

U is for Lars Ümlaüt. Lock the doors and board the windows when this shredder busts out his guitar! A Norwegian Guitar Hero who loves to crank out headbangin' heavy metal hits, Lars can often be seen jamming in his signature black and white face paint. Rock on!

Vv

V is for Tommy **V**ercetti. This Vice City legend isn't afraid to get his hands dirty. Willing to do whatever it takes — like intimidating jurors and stealing boats — Tommy uses his brains and brawn to build the Vercetti Crime Family into a powerful underworld force.

Ww

W is for Sylvanas **W**indrunner. Sylvanas' soul was transformed into a banshee after she tragically fell in battle, setting this former hero up for a journey of darkness and destruction. Now the Dark Lady uses her Warcraft mastery to rule over her Forsaken army of the undead.

Xx

X is for Mega Man X. Designed to be a bigger and better Mega Man, X fights in the Maverick Wars to save Earth from renegade Reploids. With futuristic 22nd century armor that can shoot sparks, ice, fire, and more, this bad 'bot is ready for battle.

Yy

Y is for **Y**oshimitsu. Yoshimitsu, leader of the Manji Clan, is a vicious fighter with a kind heart. He frustrates opponents with his signature mask, unorthodox fighting style, and a legendary sword that's been passed down through the clan. When his enemies least expect it, he strikes them down.

Zz

**Z is for Zelda.
Zelda is a Hyrule legend — the princess whom heroic Link fights to free from the clutches of evil Ganon! But she's not just a damsel in distress, as she honors her duty to guard the Triforce of Wisdom and occasionally help Link in battle.**

The ever-expanding legendary library

- HORROR LEGENDS ALPHABET
- COMEDY LEGENDS ALPHABET
- LIBERTY LEGENDS ALPHABET
- BASKETBALL LEGENDS ALPHABET
- DYSLEXIC LEGENDS ALPHABET
- ART LEGENDS ALPHABET
- LADY LEGENDS ALPHABET
- DRUM LEGENDS ALPHABET
- HOCKEY LEGENDS ALPHABET
- CHEF LEGENDS ALPHABET
- SURFING LEGENDS ALPHABET
- LEFT-HANDED LEGENDS ALPHABET

EXPLORE THESE LEGENDARY ALPHABETS & MORE AT WWW.ALPHABETLEGENDS.COM

VIDEO GAME LEGENDS ALPHABET
www.alphabetlegends.com

Published by Alphabet Legends Pty Ltd in 2021
Created by Beck Feiner
Copyright © Alphabet Legends Pty Ltd 2021

9780645200126

Printed and bound in China.

The right of Beck Feiner to be identified as the author and illustrator of this work has been asserted by her in accordance with the Copyright Amendment (Moral Rights) Act 2000.

This work is copyright. Apart from any use as permitted under the Copyright Act 1968, no part may be reproduced, copied, scanned, stored in a retrieval system, recorded or transmitted, in any form or by any means, without the prior use of the publisher.

This book is not officially endorsed by the people and characters depicted.

ALPHABET LEGENDS